Wonderful Bastard

Funny Swear Words Coloring Book for Release Stress

Enjoy Coloring!

Asshole

Great !

www.ingramcontent.com/pod-product-compliance
Lightning Source LLC
Chambersburg PA
CBHW081620220526
45468CB00010B/2966